SCHOOL
of
ARTS

SCHOOL
of
ARTS

LING CLARA

PARTRIDGE
A Penguin Random House Company

To order additional copies of this book, contact
Toll Free 800 101 2657 (Singapore)
Toll Free 1 800 81 7340 (Malaysia)
orders.singapore@partridgepublishing.com

www.partridgepublishing.com/singapore

CONTENTS

The Chinese Girl ... 1

So Quick .. 2

The Waiting ... 3

Hold it a little closer .. 5

Time ... 6

I've Got Only A Pair of Little Hands 11

Single .. 12

The Companion ... 13

Banana ... 14

Cattleya ... 15

Kaki Lima ... 16

In Loving Memory Of. .. 21

Tattoo .. 29

Unrequited: A Silent Conversation 37

Lucas ... 39

To people who think they are artsy enough
to understand everything;
try harder.
Embrace time. Because it never waits.

DEDICATION

To PAPA,
To my dearest Papa and Mama,
My band of brothers,
And my family,
My cheeky doggy Vera
My bestie,
My amigos
For you all.
Loves.

THE CHINESE GIRL

She had just finished her shower
When she sat on the table
She pulled her dress lower
And made sure it was stable

She took a tiny brush and painted her face
Her eyes, her lips and her cheeks.
Her mother came in and said "you're out of taste"
She covered her face and wept like a meek.

Then a voice came out of nowhere
That she jumped out from the chair
A figure came in with a stare
Shy but delighted she questioned;
"My knight in shining armour maybe?"
The figure answered:
"You look lovely!"

So Quick

Your favourite song
Played as they dressed you up like a handsome gentleman;
You wore your favourite tie and suit.
My! My! What a quiet evening when you came home,
The neighbors were busy
And church members were restless.

What a tiring day, you had
And a long weekend, you experienced.
I do not know how you feel
But I knew you love me when you called.

What a night! What a journey
When I came home to see a sleeping you,
What are they doing to you?
Torns and strings wrapped around you.
As we, your beloved watch….

At 6.41pm, your heartbeat went
from 50-33-32-34-33-20-16-17-10 to zero...

THE WAITING

You heed the call
You wait for long
You wish it now
To come to pass

You wonder along
The bright of day
The dark of night
If he recalls your very sight

Sometimes he shows
At times he don't
But there is a sign
Yet not really uncovered

Oh, the heart beats fast
The soul cries out
The spirit yearns
For a deeper warmth

Come away, beloved
Come sit by me
I want to feel you
Show me you love me

My heart is patient,
I shall wait
For the day to come
When you unveil it

Heal me please
I can't wait
I need to know
I need to know

Come away with me
And walk this path
Together we shall
Rise above all sorts

Often I wish to call you dear
But I refrain
Cause I know what you want
For now....

HOLD IT A LITTLE CLOSER

For time ticks swiftly as the birds fly across the skies
Even you try to catch it within your fingers
Time seems to belittle you
You dance around it just to linger
But sometimes it won't just listen

Hold it a little closer,
As close to your heart can be to your soul
Come and arise, don't just follow where it goes
Make it stop to cease and freeze
This little treasury of sweet occasion you and I have.

Hold it a little closer, my grandpa
Shed no more tears and live happily and long
Thomas said "Do Not Go Gentle Into That Good Night"
So promise me you will
Into the light-years to come,
You will see, you will watch me
Perform my best In front of the world,
Walking down the path where I take my marriage vow
And promise me,
You will hold my first born in your arms and
Hold it a little closer to your heart…(In Heaven above)

Hold on, Grandpa. I love you. Don't go anytime.
Promise me you will make my wish come true.

TIME

Everyone was silent as they listened to the
sound of the water from the shower
Gushing out from the shower head.
Silent, she stood
And allowed the water droplets sink into her skin
It danced down her soft skin like morning dew
Like a dancer.
A perfect scene to describe the start of a story

The shower room was filled with vapour
As she stepped out the shower room
wrapped only in a piece of towel.
Water dripped from her wavy black hair onto the floor,
Shaping beautiful water droplets on the floor mat.

Slowly, discreetly, silently, she made her
way towards the dressing table
And as everyone watched her mystique movement
There was something in her eyes
Which foretold a story of a suspense

She sat down, but nobody could see her face,
They could only see the view of her lips
It wasn't happy, nor was it sad
Then they saw her right hand,
Move to the side of the table.

Her hands were feminine like
So perfect
That everyone who was watching her
Instantly felt a sense of attraction, but mystery invaded.
Who is she? What had happened to this delicate flower?

She drew out the drawers and pulled out a dark byzantium box
She lifted the lid and pulled out another maroon box
Opening it, she drew a sad sigh.

There lay a heart-shaped necklace
It was the most beautiful piece.
Exquisite, it paired well with her fair skin.
Everyone was awed but she was silent.

Her fingers touched the diamond
Just as if it touched her own heart
There was a sharp pain that pierced through her
A silent grief
A buried misery
A deep emotion
A rustling tornado that hit her
And the audience watched
Tears strolled down her cheeks
Like droplets from the rain.
Too much water.

A deep sympathy was felt in the room. The
flowers began to sing a melancholic tune.

She raised her head, watched herself in the mirror
And for the first time, everyone saw her beauty.
Though there were tears, she had a fairness
that exceeded all women.

Her eyes were like water,
Too much, indeed
And there are deep stories in her spirit, untold
She was the most perfect soul.

She took a deep breath and wiped the tears from her cheeks,
As the flowers sang the chorus of the tune,
She brushed some powder across her cheeks,
Picked up strands from her hair
And arranged them neatly
Then a lady in red walked in the room with
a couple of small baby's breath
And pinned the flowers onto her hair.
The lady in red whispered something into her ears as smiled.
Beautiful.
She picked up her corset,
Put on a white dress of delicate lace.

The lady in red took a gold necklace out
and put it on for her.
She turned her back and stopped the lady in red.
She then picked up the heart-shaped necklace
And put it on herself.
The lady in red watched her in silence.
She felt her.

The door of the room closed. A man in tuxedo passed
her a bouquet of white peonies. He and the lady in red
walked her across the elegant and luxurious corridor.

As they exited,
Three other men stood in a line, awaiting her arrival.
The car doors opened and she stepped into the black car.

Everyone kept watching.

She stepped out from the car elegantly with the help of a man,
Who held her hand so gently.
Even he was struck by her beauty.

A man of forty received her
She held him by the arm.
The doors of the church opened and she
walked down the aisle with the man.
The place was sweetly decorated with hanging white orchids,
On each white chair, there were people seating.
But there was only one at the front row,
Which was left empty.

The man then handed her hand gently over
to another younger man of her age.
He led her down to the altar where the priest stood.
Soon after, he kissed her for the first time.
It was glorious.
Women had tears of joys, men were smiling.
For they had waited this day for such a time.
For so long.
For days, months and years.

She turned around.
And set eyes on the empty seat.
There was a man, dressed in white suit,
With grey beard, and white hair, holding
a walking stick in his hand
Who took the empty place.
He smiled at her the most handsome smile,
So gentle, so fatherly, so loving, so peaceful.
His face shone like fireflies

As she smiled back at him the sweetest smile.
He was proud. She was content.
He had kept his promise.

As the younger man took her hand and walked her out,
He whispered into her ears "He is here."
So it began their journey to a happy ending.
She turned back one last time and saw the
man had tears in his deep eyes
There was a smile on his face again.
This time, a smile of bursting joy and of a proud Father.
He thought "She's my beautiful swan."
She smiled at the man for one last time
And the doors of the church closed.

She left to rewrite the story of her new
chapter. This time, with a man.

Everyone continued to watch the scene
Where the old man stood up, walked towards the light
And on the path which his swan had walked
It slowly turned into gold and glory
He walked towards the bright light and smiled,
then laughed and disappeared.

The audience watched.
And they saw a white rose nicely placed on the empty seat
The man had once seated and then left into the light.
There was a moment of serenity.
The lady in red walked towards the seat and picked up the rose.
She looked up at the clock hanging on the church wall.

It spelled "Time".

I'VE GOT ONLY
A PAIR OF LITTLE HANDS

It's funny when people say
Don't be upset cause of a little fray
Come on, it couldn't ruin your day
Don't let out a small bray.

Are you joking with me?
I just want to be free
Not like a tree
But to at least have some glee

Don't worry about it
Cause the boot will fit
Come see and sit
Don't even spit

I just want a dance
Not to jump over the fence
Come stand at my defence
I've got only a pair of little hands

SINGLE

The heart of a woman is as strong as a lion
As brave as it can be
It is also tender
She grapples her own struggles
And fights her own battle
But in times of trouble
She may be breakable

She falls and rises
And yet she knows
After the rain comes another rainbow
In every difficulty lies opportunity
Don't focus too much
Or you'll miss the blessings life can give you

In the end,
As you wait
And allow your heart to be mended
"He will watch you get married from heaven"
And your life's course will change

THE COMPANION

Imagine this:
Two souls,
Joining into
Communion
I do not look into what you had in the past; for it had long gone
But I look into what our future hold, to rewrite our story together
In the midst of challenges, I know nothing but God be the centre
Said he
And she
To the other
Bridge the gap
For its temporary
Know the future offers
Something pleasant for both
A story of the past, present and future

BANANA

Yellow skin, black hair
Small eyes, flat nose
That can't breathe air
Nor see through a hole

Come see and not forget thy roots
You're Chinese so put on your clogs
But she's already wearing boots
Nor does she know her grandfather's clock

Aunties and uncles flood the house
On New Year's Eve where there's a crowd
Coming home like a bunch of mouse
Asking questions you know you'll drown

"Ni shi "Asian" bu shi wai guo ren"
(You're an Asian not a foreigner)
"Na ge Ang Mo Kia shi sui?" (Who is that white guy?)
"Ni dai ta hui lai ni bu pa ma?" (Aren't you
fearful when you brought him home?)
"Ta "gam" ni de shi hou ni bu yong hui lai" (Wait
till he "eats" you, don't think of coming home)

Calm down, wo de jia ren, (my family)
I may look different but I know my roots
Wo hai shi ni de bao bei nu er, (I am still your beloved daughter)
I speak English but I know I'm still Chinese.

CATTLEYA

It has a beauty and charm that mesmerizes all form
It's petals are pure, with shades of warm
It stands all tall, always still during the storm
It's heart beats and produces new corm

It has nothing but a flight of terror
It resembles you like a mirror
It won't say a word or speak of horror
For only in down times you'll see its slaughter

It is tame
Yet always the mind of a game
It dislikes to be brought to shame
Which is why it has lots of fame

So it is, the white orchid
Never once it has felt a misfit
Jolly outside but inside trying to fit
Before the white orchid falls into a pit

KAKI LIMA

Five-foot way. That's what you call it.

It was on a humid Sunday evening on April 6th when Clare and her friends arrived at a five- foot way around York Memory Lane. The next thing you know, they had bought some chicken rice from a nearby coffee-shop to feed anyone. Anyone? Yes.

"Oh, Clare. What the hell are you doing? Picking up on some street peeps? Didn't mama tell you not to talk to strangers?" said the voice in Clare's head. But it was too late to turn back now. They had arrived at the five-foot way.

"Oh, Clare. It's too late to turn back now. Just do it. Think positive," the voice tingled in Clare's head. Clare looked around and approached a man sitting alone at a corner.

"Apa khabar, uncle?" Clare said with a smile as she offered her right hand for a friendly handshake.

"Good. I can speak English you know. I obtained a distinction in English in the Malaysian Certificate of Education in the 1970s," replied the man. Clare examined him from head to toe discreetly. He was not very tall. He was skinny and looked like the darker version of Aristotle except that he had lost almost all his teeth.

"My name is Lingham. You are ….," said the man.

"I'm Clare. Nice to meet you, sir," replied Clare. "Sir, how old are you?"

"First of all, my dear, do not address me "Sir." Call me Lingham," said the man with a little act of gasping for air. Realising he wasn't feeling too comfortable, Clare offered a seat to him by the five-foot way. They moved to a corner and Uncle Lingham took out his white, old and yellowish helmet for Clare to sit.

"No, Uncle. You sit"
"No, you sit"
"No, you sit," said Clare as she sat on the dusty and cracked mosaic floor.
"No, you sit," Lingham insisted.
"Uncle, no. Take this seat. You deserve it". Uncle Lingham was silent for a moment as he sat gently on his helmet. Staring into her eyes, he knew he had found a friend.

"Never had I communicated nor sat with anyone from an upper class caste before. I had never seen any lady from an upper class caste reaching out to someone in the lower class caste. By right, it should be me who's supposed to sit on the floor," explained Uncle Lingham. "It is my first experience".

A friend? Clare never really had any best friend in her life. All her life, she had trusted no one. But Uncle Lingham was different. He had this fatherhood in him that drew Clare to him. "Uncle, how old are you?"

"Fifty-seven."
"Fifty-seven? But you look young!"
"No, I don't," said Uncle Lingham with a laugh. "You know, I was on my way to the hospital when I saw a crowd gathering here."
"Uncle, where is your family?" asked Clare.

"They are dead. I'm the second child. After I was released from prison, I have been a transformed man and so is my life."

"You were in prison? Why?" gasped Clare, staring at him, scarcely able to believe her ears.

"Drug addiction but I overcame it after a tough battle with my mind and will."

"I see..Uncle, you speak very good English."

Uncle Lingham laughed. "It was back then when I was in school. I was very inspired by my English teacher. She taught me how to master English. Sadly today, the zealous determination to master it is fading. You know, girl, do what inspires you most."

Clare smiled and said, "Uncle, I'm actually studying English and I love reading."

"Oh really? You're a bookworm then?"

"Yes. I love reading classic novels and poetry."

"Reading is good. It gives you knowledge and wisdom. You know, some writers do a lot of research before writing. So when you read a book, you are reading about cultures and knowledge and it is something that is priceless."

Clare was stunned by his words. Never did she realise she could learn something from someone without paying a price, someone who was homeless. Uncle Lingham told Clare he was a tramp. His dwelling was everywhere around the city, in hospitals, markets, parks, streets and even under the bridges.

Something sparked within Clare. She went home with a new perspective, jotting down a long list of her encounter with Uncle Lingham in her journal. She wrote and wrote and fell into a deep sleep.

The very next day, she brought along a book with her to look for Uncle Lingham. There! She spotted him, purchasing an inhaler for his asthmatic attacks.

"Uncle Lingham!" cried Clare as she ran across the street towards Uncle Lingham.

"Hi Clare! What are you doing here?" answered Uncle Lingham, beaming with joy on his face to see his dear and new found friend running towards him so enthusiastically.

"I brought you a book. Let's read together." Then, both of them settled down under a tree near a pharmacy and read the first page of *Don Quixote.*

"Idle reader, without an oath thou......" Uncle Lingham continued reading as Clare listened attentively, paying much attention to every word read by Uncle Lingham. He read so well and there were sparkles in his eyes as he read. He held the book tightly and flipped through the pages with his rough hands. Clare watched and admired every gesture he made.

Hours passed. Days passed. Weeks passed. This was Clare's routine everyday after her classes. She would look for Uncle Lingham and they would sit under the same tree, spending much time together. Such close bond of friendship was born between Uncle Lingham and Clare.

Clare enjoyed his company as a dear friend. They would share their thoughts and ideas about cultures and life. Uncle Lingham was indeed a man who had the whole universe in his mind. Inspite of his shabby clothes, dirty face and rough skin, he had one thing which captivated Clare's heart: WISDOM.

Years passed and one morning, Clare got out of her bed and went to her usual meeting place with Uncle Lingham. She waited and waited. Hours passed. She waited patiently. Hundreds of cars passed by and the weather was extremely hot that day. She looked around and there was no sign of Uncle Lingham. Dusk came and Clare looked down the street once again. There was still no sign of Uncle Lingham. Her heart felt heavy. What if something had

happened to him? He wouldn't have just left her waiting under the tree, would he? Clare looked at the tree trunk and placed the book she had brought on the dusty ground. Suddenly, she spotted a carving on the trunk. It read:

"Remember 6.4.14, Clare. Love, Lingham."

Chills flowed down Clare's spine. Cold sweat dripped down her forehead. 6.4.14, that was the day she met Lingham. Clare looked around the street. The buildings were different. The pharmacy wasn't there anymore. How long had she been asleep?

It is a bond of friendship between a girl and a homeless man that is sighted as a heritage in the hearts of everyone at the "Kaki Lima."

It is a midst but it is real.

In Loving Memory Of...

He was an extraordinary man. Intelligence followed him. Kindness was written all over his face. Gentleness presumed his heart's core. Love flowed out from him like a rushing wind and a mighty river. Goodness embraced him. Patience consumed him. Passion outburst from within his very soul. Fatherly love reflected the way he lived. Meekness exerted from his inner being. He was a great man. He was a genius. He was remarkable.

Dear reader, I do not intend to make this book "just simply a book" that praises his good deeds and personality. I intend to make this book a memory. That he may continue to live through the minds of all readers. That he will continue to touch lives. That was his dream. And this is my family's dream.

You see, reader, you will never understand the heart of a father until you have become one yourself. You will never understand true loss and suffering unless you yourself have experienced it. You cannot utter that you love someone unless you have experienced love for yourself.

Grandpapa was born on the 5th of January 1930. He was a man of few words. Not many people knew what he was saying or thinking. He was an intelligent man one can tell so obviously. He was wise. He spoke very little but when you fix your eyes upon him, you see love. You see gentleness, you see meekness, you see showers of bountiful love pouring out form him. He was a spiritual man, a powerful preacher. His sermons carried weight. He walked the talk.

Let us make this chronological. Grandpapa was the eldest among four siblings. His father was a womanizer, an alcoholic, not a very good man nor a good father. The only person that loved him the most before he came to know about Jesus was his mother. Come what may. His mother died of childbirth when he was thirteen. Being a village boy, he had never been out of it. So one fine day, his father promised him to being him out of the village. He put on his best, got ready and waited by the gate for his father to come home and bring him to Ipoh. He waited, waited and waited. Minutes and hours slipped by slowly, coldly and silently. His father never turned up. At that very moment, he vowed "I will never let my children nor my children's children to experience the pain I had to go through". He kept his word. Not his children nor his descendants suffered.

He was really good in sports. A runner to be exact, a champion. He won many medals and awards. He played in the school's basketball team. He scored. And he was pretty into a very beautiful woman: my grandmamma. He loved her. When his friend just got his driving license, he asked his other three friends for company to take a peek at my grandmamma at her home. They parked the car by the slope near the basketball park. Being a green-horned driver, his friend had forgotten to pull the hand brakes. The car went down the slope and instead of chasing the girl, they ended up chasing the car instead.

Months later, he took the courage to visit my Grandmama's parents to ask for their blessings to date their daughter. Grandmamma had six sisters including herself. Great-grandmamma disliked grandpa because he was poor but great-grandpapa believed in him. They got married anyway.

Life was not easy though but grandpapa never grew tired. He wakes up early in the morning at 1am to tap rubber, goes back to prepare his kids for school, goes to school to teach, comes back and prepares his kid's meals, guides them in their homework, visits

people and at night he goes to church for prayer meetings, comes home and retires.

Now my aunt was asthmatic. One day, uncle, daddy and her were playing by the riverside near our home and aunt secretly bought some shaved ice. Grandpapa came home from school, cycling his usual old and trusty bicycle. From a distance, he saw aunt eating shaved ice. He got down from his bicycle, went towards aunt, took the shaved ice from her and threw it into the riverside without uttering a single word and cycled home. Look at how concerned he was for her. No words, just actions, actions and actions.

They could only afford a packet of peanuts once in a blue moon. When they could, grandpapa counted the peanuts and distributed them equally among his three children and his lovely wife, not leaving a single thing for himself. This is what I call "sacrificial love".

During every Chinese New Year, Grandpapa would prepare our usual traditional meals and delicacies to celebrate this joyous reunion: Mee Suah, Yee Sang, Popiah and so on. You name it, Grandpapa prepared it. He was the best chef! Back then, our kitchen did not looked like how it did today. We used a large metal stove which required a light gun to light the fire. With Grandpapa's muscular body and well-built size, it was easy for him to handle the large stove.

When I was little girl, helped me put on Grandmama's helmet. "Oh, another shopping day. I'm going to get that pink Barbie doll I had always wanted," thought my little mind. He brought me to every supermarket in town later that afternoon, searching for the perfect helmet for me but not one actually fit. So he bought me the doll I always wanted and then headed home for dinner.

The next day, Grandpapa came home with a brown box. "Clare," he called, "come here". I wobbled over like a penguin and he laughed.

He opened the box and unwrapped the box. Out from the box he took out a blue Dolphin helmet. Mama told Grandpapa that I am too pampered by him. Grandpapa helped me strap in the helmet and brought me out to town again. What a proud little girl I was, showing off my new blue helmet to the people in town. Most of all, I wanted to show off what a great Grandpapa I had.

His ministry expanded. He said he wanted to leave earth while preaching on stage. He travelled. He shared stories with us about how the church in China had underground churches during the Communist reign. He and a few companions had to run in the middle of the night to avoid being captured. How Grandpapa risked his life for God.

He told auntie about how he remembered when I was a little girl and he was in the hospital receiving treatment after an operation, daddy and I went to pay him a visit. When daddy was about to leave, I asked daddy to put up a night with him in the hospital and daddy did. He admired me for my intelligence.

He remembered how when I was three or four, he was reading the newspaper at the table, I climbed up to his lap and called him "gong gong!gong gong!" (grandpa! granpa!) He continued reading the newspaper and pretended to not notice me. And I grabbed his cheek with my two little palms and he looked at me. I asked him to take me shopping. He said why not ask mummy? I said no. He asked me "Why not?" I replied "Ying wei wo ai ni gong gong(because I love you, gong gong)"

He taught me about finding the right life partner, how to test if he is sincere. Make a brick wall out of paper and tell the man "If you love me, bang your head on this wall" or make a cup of coffee and say this "I put some poison in this cup of coffee. Drink it if you love me". Of course, you don't actually mean that. Replace it with some nice coffee instead.

On December 12th 1999, Grandmama laid on her deathbed. Grandpapa really loved her. Grandpapa sat right next to her by the bedside, spending every single last moment with her. His wife, his lady, his love. The final moment. She was about to leave him to return back to Jesus. When she drew her last breath, I turned my little head back and saw Daddy stepped right into the hospital door. When I turned over to look at Grandmama, she was gone. I saw how Grandpapa sobbed and grieved beside her cold, lifeless body. It was a grief that it incomprehensible and unimaginable. He sat there right beside her body for a long time. Uncle went over and gave him a pat on his shoulders. She was gone.

The next few weeks trying to bring back the joy in Grandpapa was difficult. Grief was written all over his face. Daddy took us on a family trip to an exclusive five star resort with sandy beaches and then an escape to the highlands, hoping to cure and ease his pain and lost. But somewhere written beneath his shadow and hidden inside his eyes, an elegiac story was buried.

Dear reader, don't go just yet. Please, read on.

Grandpapa departed. Ironically, the day Grandpapa departed was the very same day in which Grandmama departed: a Sunday.

He raised many people. Do not feel obliged. We all are his kids. As Abraham fathered many nations, so Granpapa is a father to all. Grandpapa is a living legacy.

I recorded the last few days of my own experience with Grandpapa in a book and I decided to place the very last few writings I wrote for Grandpapa inside his coffin. But I am going to share this with you. These writings are not just diaries, but memories I have kept inside my heart.

June 28th 2013, 11.33p.m

Mummy sent me a text message saying that Gong Gong (Grandpapa) was not eating well, having diarrhea, not sleeping well and getting thinner and thinner than the last time I saw him. You see, he had to go through prostrate operation which made him thoroughly weak and almost dehydrated. Saddened, worried but I thought I'll call home tomorrow evening.

June 29th 2013, 10.20 am

I woke up this morning to a voice inside of me urging me to call him the minute after I had taken a shower. I called him at 10.20 am. Never knew this was the last time I listened and heard his voice. He had this deep, soothing, calming and gentle voice over the telephone. He sounded happy and vibrant when I called him. 2 minutes. Only 2 minutes. I remembered him giving me RM 100 for my daily expenses for university use. I did not use it, Gong Gong. I kept it because it is so dear to me and it is even dearer now. I almost used in during a lunch trip with my friends to Nandos. But I asked the waiter to return it to me. Thank goodness I did. "Jiao hui de dong xi zuo duo yi dian mei guan xi"(It's alright to be a lot more spiritually committed) "Du shu hai hao ma?" (How's studies?)" Wo kan dao ni de tu pian. Shen hui zhu fu de" (I saw your paintings, God will bless you) Little did I know that 2 minutes was so much more precious than rubies and sapphire. I was at the Victoria Street Project when I got the news from Mama that Grandpapa had a fall. In the evening when I called home again, Mama said the neurologist could do nothing about

it. He had been declared brain dead. His brain had shifted. My heart shattered. I needed to go home.

When I arrived at the hospital past midnight. There he was, laying on the hospital bed with life support machines plugged inside his throat. He look skinnier than usual. I could see his bone structure. I did not know how to react. Looking around the hospital room, it was crowded with so many other patients. Some were with their wives, some were resting. And I looked at Grandpapa once again. He was not moving at all.

June 30th, 2013.

We all heard stories before that when a person dies, his or her soul will linger in the room for a few minutes. I wonder how true is that. If it is, I would love to take another look at Grandpapa.

Our entire family surrounded his bed on that very solemn day. We sang songs for him. Basically all his favourite songs.

At 6.41pm, your heartbeat went from 50-33-32-34-33-20-16-17-10-0.

Millions of people mourned the thousands of lives lost during the sinking of Titanic. But compared to the pain we all felt when your heartbeat sank to zero, this was piercing through our hearts like a double-edged sword. Strangely, when your heart stopped, there was a calm feeling, angels were around. Nobody cried. Only silence was

present. But after seconds, the melancholic feeling resurfaced. You are now gone.

The last time I touched your hand and tell you that I love you very much and thanked you for all the toys you have bought for me. Auntie said you wanted to leave while preaching on stage. Grandpapa, you actually did. Even on your deathbed in the hospital, you were there holding our hearts together. You were touching us. You held us strong together as a family.

That very evening, my brother and I lit a candle and sat by the swing you sat with Grandmama and talked about you, looking at the sky. It was the brightest night ever. There was an uncountable number of stars in the sky. "Always remember him as a healthy man," my brother told me.

That night when your body was brought home, my doggy, Vera, was restless. She knew something was wrong. So we brought her in to visit you on your white bed for one last time. She circled around you and let out no sound. She knew you were gone. She was sad.

Reader, again I remind you. I don't mean to tell you everything, but this is the story of something I had buried in me. Every now and then, I think of him. There's a grief that can't be spoken, there's a pain that goes on and on. But still. There's only one thing that remains: a memory of a family that stays together until the end of time.

It was almost spring when the flowers start to bloom outside the window. So the writer closed her book. She stared out her window. She moved reached out for her glass of wine and took a sip. With that, she ended her story and left the room. A ray of sunlight entered the room and shone on the book she had abandoned for centuries, waiting someone to uncover it.

TATTOO

"Louisa...my darling girl. When you grow up, you're gonna be the most beautiful person," Papa Max exclaimed as he chuckled when baby Louisa sneezed.

She giggled as Papa Max continued to tickle her. Papa Max carried her out of her pink play pan and held her tiny hand in his. His big hands gripped hers as they walked across the silent evening street for a cup of hot chocolate in their favourite cafe: Tattoos.

"Louisa! Have you been a good little girl?" asked Margery.

Margery has been working in Tattoos for the past eight years. She was a victim of child abuse during her younger days. Margery was often tormented by bad dreams of how her father used lighted cigarette buds to punish her for not getting good grades in class. Her father came home drunk every night and when her mother tried to attend to him on one occasion, he pushed her and she fell to her death from the nineteenth floor of their run-down apartment. She was only eleven then. Poor thing. To imagine a little girl had to witness how her mother died must have left a huge scar on her.

She had attempted suicide several times but somehow, she knew she had to live because she believed one day, she will be an impact to others. But it wasn't an easy journey for her. She was troubled emotionally, often hearing voices asking her to end her life. She battled with depression and fear of people. Thank God for Keith who was her rescuer. Keith was a practicing doctor and he was on

his way home one day when he saw Margery walking towards the water, ready to drown herself in the lake.

Though they were strangers, he walked towards her and pulled her out, clothed her and said, "You have a choice to live while others don't. You are more than what you think you are."

His words touched her, for the first time in Margery's life, she experienced what real care truly is. The world isn't as bad as how we paint it to be it seems. So it began: the story of Keith and Margery.

Margery loved Louisa because she is such a darling. She had long, straight beautiful black hair. Her bangs were cut across her forehead and she had this cute and sweet dimples on her cheeks when she smiles. Every evening, Papa Max and Louisa would head over to Tattoos and Margery would give Louisa free chocolates.

"Don't take too much of these or else the tooth fairy will visit you," said Margery.

"Pooooo Feiiiriii?" Louisa asked as she smiled at Margery, exposing her two missing front teeth.

Margery giggled and said "Give Mama Margery a kiss and you can have more."

So then it was, time passed. Leaves wither during autumn. Louisa grew into a fine young lady. She was an intelligent student, very artistic. However, like any other teenage girl, she started to explore the temptations of life. Louisa had this friend, Luke, who was a really bad influence over her life. Little did she know that her friendship with Luke had actually caused her to be distant from Papa Max. She would come home drunk at night, getting high and sometimes saying bad stuff to people, including Papa Max and Mama Margery.

Louisa was on her way home with Luke from school one day when she saw Papa Max helping an old lady pick up some old, recycled boxes. Papa Max instantly noticed her and called her.

"Louisa! Come help this lady here. Come, my girl," he exclaimed happily with a kind smile on his face.

Louisa heard Papa Max and she felt it was a disgrace for her to go over.

Luke said "Is that your father? And is that old woman your mother?" Louisa's face turned red.

"Shut up, Luke. Let's get going," said Louisa as she grabbed Luke's arm and ran across the opposite direction. Papa Max's eyes followed her as he watched her running away with a stranger boy. He let out a sigh. Disappointing, really.

Papa Max went home that evening feeling like a huge cloud of darkness. He looked around his empty house. It was different, really different. He walked towards the fireplace and picked up the photo frame of Louisa's late mother.

"Karen, our daughter's changing. I wish you were here. I can't do it without you," Papa Max cried.

Tears rolled down his ruddy cheeks. His once cheerful face was no longer jolly. He took the music box and opened it. A little ballerina popped up and starting dancing to a strange melodious tune. Papa Max laid his head to rest on the couch and soon fell asleep.

"Daddy! Daddy! Help me! No! Stop it!" shouted Louisa.

"Louisa! Louisa!?? Where are you!? I can't see you!" Papa Max shouted back as he tried to find his way through the mist of the night in the strange looking jungle. His heart raced. Suddenly he heard Louisa's screams echoing among the trees and there was a silence.

"Louisa!!!!!!!!" shouted Papa Max.

Papa Max jumped up from where he was sleeping. Cold sweat dripped down his wrinkled forehead. He felt something was wrong. His instincts had never lied to him. He ran upstairs into her room and found no one. He grabbed his bunch of keys and drove his old Corolla. He searched high and low for Louisa around the neighbourhood, knocking on every door, hoping to find his little baby Louisa but she was nowhere to be found.

"God, she is my girl. Please. Keep her safe." Papa Max prayed.

As Papa Max steered his way around the corner of a dark alley, he noticed a familiar figure. Louisa! He caught her red-handed with Luke. Papa Max was in a rage. His heartbeat increased and blood pumped through his veins. He was angry. He dashed towards Luke, pushing him towards the wall.

"Daddy!" shouted Louisa. But nothing could hold Papa Max's anger.
"Stop it, daddy!" For the first time in her life had Louisa ever saw her loving father, turning into an angry person. She was frightened. She trembled and tears rolled down her cheeks. Papa Max grabbed his fist and lifted his hand, ready to give Luke a punch when Louisa's frightened look caught his attention. All of a sudden, his heart started to calm down. There was a long silence.

"You can either choose to show Louisa how violent you can be or you can choose to reveal your nature as a loving father to her," a voice whispered into Papa Max's ears.

Papa Max came to his senses. He put his fist down, took off the black and white checker shirt he was wearing and covered Louisa. Like a father who loves his babe so much, he led her into the car and drove home. The entire journey was the longest journey home. There were no words uttered from the mouth of the father or the daughter. Only plain silence.

When they arrived home, Papa Max brought Louisa into her room. Louisa removed her makeup which had been smeared and took a long shower while Papa Max waited outside her room. Papa Max then walked into the kitchen and grabbed a bottle of beer. He sat down at the balcony on his late wife's favourite swing and counted the stars. When he had finished, he left the bottle on the swing and went into Louisa's room. He caught her sobbing. Saying nothing, Papa Max held her gently by her hand and led her towards the mirror. Papa Max held her in his big arms, giving her a warm embrace. He placed her head on his chest and hugged her tightly. He could see tears rolling down her face.

"Louisa, open your eyes and look into the mirror. What do you see?" Papa Max asked. Full of regret, Louisa let out a deep cry and held her papa tightly.

For months, the father and daughter were inseparable. Every night, Papa Max would bring Louisa in front of the mirror in her room, embrace her with loving arms and ask her what can she see in the mirror.

After a year, Louisa got better and she was a totally different person. She no longer struggled with identity issues for she knew who her father was and who she was to her father.

"Daddy, look." Louisa said as she handed Papa Max a letter. "I've been accepted into the University of Francesco."

"Honey, I told you! I'm proud of you!" Papa Max hugged her and the both of them laughed and giggled like how Papa Max used to giggle at Louisa as a little child.

The day came when Papa Max had to bid Louisa farewell. He prepared her favourite Ceaser salad and French toast with hot tea for breakfast.

"Are you sure you're gonna be fine?" asked Papa Max.
"Of course, daddy. I'm a university student now. The bus won't hurt. I can make it," replied Louisa.

Papa Max dropped Louisa at the Raiderman Bus Station. He carried her luggage and made sure Louisa is nicely tucked in her seat. When the bus left, Papa Max knew he could only hold her up to a certain age. It was time for her to make her own decisions. When the bus left, so did Papa Max.

Six hours passed by and there was a knock on the door. Papa Max opened it....It was a policeman.

Papa Max felt like his world came crashing down in seconds. He drove his car as fast as he could to the hospital.

"God, please no. Please, not my baby Louisa. Not now. Not today."

It was a sombre moment. When he arrived at the hospital, he saw many other parents, some teary, some fearful who were waiting outside the intensive care unit section. Suddenly, the doors opened and the nurses and some doctors escorted four bodies, covered in white sheets out from the room.

"Mr. Jefferson?" a doctor called.

Papa Max walked into the mortuary. He felt like his soul had left him. In the room, he saw Louisa. Her makeup was gone, her face was pale and there she laid, motionless. Papa Max moved towards her, touched her once warm but now cold cheeks. He couldn't help it but fell to his knees and let out a deep, loud cry. He sobbed uncontrollably.

"Karen, our baby girl. God, not now. Why now? I love Louisa with my life don't take her from me. She's just a girl. Not today, God. Not today," Papa Max grieved.

There were 127 people who attended her funeral. You can tell how Papa Max was sublimed in his misery. He loved Louisa very much. He held a white Lily in his hand all the time for it had been Louisa's favourite flower. Rain fell and covered the earth. Nothing could heal Papa Max's heart for it was there was a deep grief in his soul.

Papa Max went into Louisa's room to pack her belongings after three days. He found a diary and flipped through the pages carefully. One by one, he read them out loud. On the last page, he read:

> *Dear diary,*
> *I'm so excited to get to university finally. It's today! However, I am sad because I'm leaving home. How would daddy feel? He always forgets to switch off the gas stove and forgets where he puts his glasses all the time. He should probably get Mama Margery and Uncle Keith to stay over until my break starts. I'm worried about him.*
> *But it's gonna be so cool. I can't wait to start this new chapter of my life. So here's 10 things I want to do the minute I touch down in my university:*

1. *Have some chocolates on the bus.*
2. *Pack my pink ballerina shoes.*
3. *Say goodbye to Mama Margery and Uncle Keith.*
4. *Fold my blanket.*
5. *Grab my ukulele and smuggle it up the bus.*
6. *Don't ever forget my water bottle.*
7. *Pat Betsy the dog before getting up on the bus.*
8. *Get my sunflower dress.*
9. *Grab my diary.*
10. *Tell daddy that the only man who will never hurt his daughter is her father.*

Daddy, all this time when you held me in front of the mirror, I've never said a thing about it. But I want you to know that I see a father who loves his daughter very much whenever I look into the mirror. I love you, daddy.

"I love you too, my baby girl," Papa Max cried.

So it was, the story of the father and his daughter. Papa Max continued to live until his old age. He somehow seemed to recover very quickly. He started a center for young people to find shelter from anxiety, depression and some sort of things related to it. Every morning Papa Max still drops by for his usual hot chocolate. He would say to me "Margie, do you know how proud I am as a father to Louisa? She is my daughter no matter what and always will be." Louisa…. "A tattoo on his heart"

UNREQUITED:
A SILENT CONVERSATION

Daughter: Again. Again. I saw him. Right there. How he haunts me in my sleep. My heart is torn. How, my dear? You came and then you ran away. Snatching everything I have. My heart inside my chest pumping like a raging lioness. A dagger. Like a dagger in my chest, this is how you ran away! Pain. Run away! How fragile my heart seems to be. He was standing there! Now he's gone. He asked me to look into the sky and count the stars for each of them represent the dead watching o'er me. But now, where is he? Dead or alive?

(Mother enters)

Mother: My dear, sing with me, my dear. Don't look up into the sky. It'll hurt your gentle heart. He's gone, not here at all. Don't think, it's disappointing.

Daughter: Don't shy me off, mother. Don't shy me off. I know he's here. He's there somewhere.

Mother: He's dead and gone.

Daughter: No! He's here. I saw him. I saw him looking into me.

Mother: What do you expect from a girl like you? He's not here. Never here. He won't return nor will he come.

Daughter: He captured me. He ransomed me in his palm I can't escape.

Mother: He does not exist. He's a fool, he's a bad man, he holds your heart tight and will break you apart.

Daughter: No he won't. He's gentle, he's the future.

Mother: Poor girl, poor girl. Ravished by an unrequited force. Unrequited manner. Unreturned prospect. It is all fated. All written by the hands who writes our lives. This girl I see is such a beauty but such a great misery. Within her, how can he exist?

LUCAS

CHARACTER LIST

Main character: Lucas
Scientist: Charles
Husband: Matthew
Wife: Jane
Son: Jason
Doctor
Old lady
Robot animals (Bear, fish, lion, bird)
Robot insects (3 insects: Martin, Leo and Smith)
Caterpillar Nana
Blue Fairy (a futuristic lady scientist)
Chinese, Indian and Malay Villagers

SCENE 1
(On screen)
(Footages of futuristic people, vehicles, streets in between)
Year: 2200
Venue: New York City

In the home of a scientist, Dr. Charles. He has lots of puppets in his laboratory.

Charles: *(talking to all his puppets)* Once upon a time there lived a good king and his queen. They had no children for many years and

were very sad. Then one day, the queen gave birth to a lovely baby girl and the whole kingdom was happy. There was a grand celebration and all the fairies in the kingdom were invited. But the king forgot to invite an old fairy. She came to the celebrations but was very angry. Soon it was time to gift the baby with special wishes. The good fairies wished her well and said, "May she grow to be the most beautiful girl in the world! She will sing sweetly and dance so well! She will live happily!" All the fairies blessed the baby and gave her beautiful gifts... Beautiful gifts? Children? pfft! I have all the puppets I want to keep me company as you see. I do not need children. Well, as a scientist I am the most celebrated one in the whole of New York City. *(pauses)* but how pleasant it will be, to just have a little company at home. Someone to talk to... *(pauses a moment)* Ahah! Let's see what we have. *(searches his toy box, hums a tune and starts putting parts of toys/bodies together and finally creates a robot puppet)*

A child...a robot that dreams.. a perfect child who can love, never falls ill and never changes. I shall call you...Lucas. I should present this boy to Matthew, my neighbor and his wife, Jane. Poor thing, their son is dying. Alright, Lucas. Let's get dressed and get going.

SCENE 2
House of Matthew and Jane. Their son is seen lying on the bed, very sick. (Charles knocks on the door and Matthew opens it, wiping his tears)

Matthew: Ah, Charles! Good evening. Come on in.
Charles: Good evening, Matthew, Jane. How's your little boy?
Matthew: He's..not too well.
Charles: Matthew, as your neighbor, I can do nothing but to pray for your son's health. But just a small favour from me to you. Here you go. This is Lucas. A child, a robot that dreams.. a perfect child who can love, never falls ill and never changes.

(Matthew and Jane look skeptical)

Charles: Anyway, it's your present. It's late now and I have to take a leave. Good night, sir. Ma'am.

(Charles leaves)

Jane: What were you thinking!? I can't accept this robot! He can't take the position as a substitute as our child!
Matthew: You don't have to try to accept him. Charles gave it to us and now he has left. It's too late to return him. Jane, he could keep our child company until he..*(pauses and looks sad and helpless)*
(Lucas walks over to the son and plays with him)
(Matthew and Jane looks from where they are standing)
Lucas: Hello, Jason. My name is Lucas. Let us play hide and seek.

On screen/Narration: Months pass by quickly and Jason's health soon improved.

(enters Doctor to check on Jason's health)

Doctor: Surprisingly, Mr. Matthew and Jane. Your son's health is improving.
Jane: All thanks to Lucas who has been a great companion to Jason.
Matthew: Thank you Doctor.
Doctor: Keep him in your arms tight and help him stay happy.

(Matthew and Jane is seen caring and loving Jason more)
(Lucas is seen sitting on the floor, a sign that he does not have the same position as Jason)

Jason: Lucas, when is your birthday?
Lucas: I never had one.

Jason: Lucas, what can you remember about the first day you were born?

Lucas: A star.

Jane: Time for bed, Jason. Come here. Let us continue our story from where we had stopped. So Pinocchio worked until midnight, and instead of making eight baskets, he made sixteen. Then he went to bed, and fell asleep. As he slept, he dreamt he saw the fairy, lovely and smiling, who gave him a kiss, saying, 'Brave Pinocchio, in return for your good heart, I forgive all your past misdeeds. Be good in the future, and you will be happy.' Then the dream ended, and Pinocchio awoke, full of amazement. You can imagine how astonished he was when he saw that he was no longer a puppet, but a real boy, just like other boys.

Lucas: A...real....boy...Love..I want mummy to love me more.
(Lucas runs over to Jane and trips over her, pulling her hair)

Jane: Lucas! Stop it! Oww! Get out! Lucas! You will never be my son and you are not real! You belong elsewhere. You will never belong to this family!

SCENE 3
(As light dims and focuses on Lucas, Lucas runs out of the room into the forest and begins his adventure)

Lucas: If Pinocchio becomes a real boy and...and I become a real boy I can go home and mummy will love me more. The Blue Fairy made Pinocchio into a real boy. She can make me into a real boy. I must find her, so I can become real. There must be someone who knows where she lives.

(An old lady appears)

Old lady: What is your name?

Lucas: My name is Lucas.

Old lady: Hello, Lucas. Nice to meet you. How old are you?

Lucas: I do not know.

Old lady: Are you alone? oh, you poor thing. Let me take care of you and show you around this forest.

Lucas: Do you know where the blue fairy lives?

Old lady: Why, blue fairy?

Lucas: I want to be a real boy.

Old lady: Why, I do not know where the blue fairy lives but come. Let me show you to some friends.

(Old lady whistles and robot animals come out from their hiding and make funny, robotic noises)

Old lady: Hush now! This is Lucas. I said hush now!! *(Animals silent)* This is Lucas. Be nice to him.

Robot bear: Look at the moon! It's so pretty.

Lucas: Is that real?

Robot fish: Of course it is

Robot lion: I do not know, Lucas.

Robot bird: It must be real. Otherwise how will you be able to see it?

Robot lion: I can't tell if it is.

Lucas: Let's go to that direction.

Robot fish: Where are we going?

Lucas: This way.

Robot bird: Are you running away?

Lucas: After I find the Blue Fairy, then I can go home. Mommy will love a real boy. The Blue Fairy will make me into one.

Robot bear: Blue fairy? Is it a robot, man or woman?

Lucas: A woman.

Robot bear: I know! Let's head to Valentine City. It's just across the East Coast. Too far for our feet. We'll need help to get there. Old mama!

(Old lady whistles and a spaceship appears)

(They hop into the spaceship)

Robot bird: Are you sure you know how to drive this, bear?
Robot bear: Of course I do.

(presses wrong button and hip hop music bursts out loud)

Robot bear: Opps. Wrong one.

(presses wrong button again and spaceships starts shaking)

Robot lion: It's the wrong one! Push the red button!

(Robot bear pushes the res button and spaceship flies)

All: Whoaaaaaa!!!

SCENE 4
(spaceship arrives at Valentine City)

Robot bear: Martin! Meet Lucas.
Martin: Hello, Lucas. Welcome to Valentine City and you are our honoured guests. Let me introduce you around. This is Smith and this is Leo. In Valentine you will find all the women you want to fall in love with.
Lucas: I just want to look for the Blue Fairy.
Martin: Blue Fairy?
Robot bear: He wants the blue fairy.
Leo: Never heard of it.
Martin: She lives right down the alley. Let me bring you to her.

SCENE 5
(Caterpillar Nana, a fat and blue caterpillar is seen on stage)

CN: Knowledge is reasonable. Welcome to Caterpillar Nana's consulting firm. Where we feed hungry minds and we serve up to twenty four hours to free consulting nationwide. There is nothing I don't know. Just ask Caterpillar Nana.

Lucas: Where can I find the blue fairy?

CN: Question me and you must pay the fee, three for seven dollars and you receive one free!

Lucas: *(passes CN cash)* This is all I have. Where is the Blue Fairy?

CN: The blue fairy is the smallest species of penguin. It grows to an average of 33 cm (13 in) in height and 43 cm (17 in) in length, though specific measurements vary by subspecies. It is found on the coastlines of southern Australia and New Zealand, with possible records from Chile. In Australia, they are often called fairy penguins. In New Zealand, they are more commonly known as little blue penguins or blue penguins.

Lucas:Who is the Blue Fairy?

CN: Are you sad and lonely? Are you looking for a mate?

Lucas: What is Blue Fairy?

CN: The Fairy with Turquoise Hair is a fictional character in Carlo Collodi's 1883 book The Adventures of Pinocchio.

Lucas: That's her.

CN: You must know that the child with blue hair was no other than the good hearted fairy who had lived in that wood for more than a thousand years...

Lucas: That's her! How can the Blue Fairy make a robot into a real, live boy?

CN: Come away with me my child, to the waters and into the wild forest, with a fairy together in my hand, with a magic wand, before you understand, your request is beyond price.

Lucas: Please, tell me how to find her.

CN: It is quite impossible. She only exists once in a thousand years.

Lucas: There must be a way…

Robot Bird: *(walks over to Lucas and pats his shoulder)* Lucas, don't be discouraged. Perhaps, there is always another way. After all, whenever there is a will, there is a way. Correct???

Robot Fish: Of course, Lucas. I know a place where we may be able to find your Blue Fairy.

Robot Bear: Now, that's very helpful. Why didn't you mention this earlier? We did not have to travel this far.

Robot Fish: Sheesssshh! Quiet, Bear. *(to Lucas)* I remember my mama used to tell me this: the secret to discovering the Blue Fairy has been allocated to a village of 3 different kinds of people.

All: Where?

Lucas: Let's find out.

(Lucas types on screen: Location: A Village With 3 Kinds of People. Time: No idea)

SCENE 6
(Arrival: The Village of Malaya)
(Chinese villagers were dancing and playing firecrackers)
(Suddenly, the spaceship appears)
(Villagers started screaming)

Villager 1: What is that??

Villager 2: Aliens!!!

(Lucas and friends step out of the spaceship)

Lucas: Hi, my name is Lucas. And these are my friends.
(Villagers start whispering in Chinese)
Robot Bear: We are looking for the Blue Fairy! Bring her to us!!!

Lucas: Bear! That's too harsh. Hi. My name is Lucas. May I know where the Blue Fairy is?
Villager 1: Blue fairy?

(Villager 1 turns to the other villagers and started to discuss softly. Then all starts screaming)

Chinese Villagers: Blue fairy!!!!! Blue fairy!!!!
(Malay Villagers appear)

Malay Villager 1: Huh? Kamu panggil saya???
Chinese Villager 1: Nah, Lucas.. "Poo faily"… "Poo faily"

(Lucas and the rest confused)

Lucas: errr…….We are looking for the Blue Fairy..
Malay Villager: *(pointing to himself)* Blue Fairy!
Chinese Villager: *(pointing to the Malay villager)* Poo faily! Poo faily!
Lucas: No no! I'm looking for a BLUE FAIRY
Malay Villager: *(pointing to himself)* Blue Fairy! Blue Fairy! Ish! Tak paham betul orang ni.
Chinese Villager: *(pointing to the Malay villager)* Poo faily! Poo faily!
(Indian villagers enter)
Indian: Relax, my bro.
Lucas; Oh thank God! Finally someone speaks English.
Malay and Chinese Villager: Blue Fairy! Blue Fairy.
Lucas: I'm looking for the Blue Fairy. Do you know where she is?
Indian: *(to Malay and Chinese villagers)* Dia sedang cari Malaikat Biru.
Malay: Ohhhhhh! Patutla aku tak paham. Cakapla Bahasa.
Chinese: Dui Dui Dui Dui Dui!
Indian: *(to Lucas)* My boy, we do not have a Blue Fairy here but I know where she is. My God up there told me that the key to find the Blue Fairy lies in the year 2020. In New York City.

Lucas: Ah hah! Dr. Charles! He might know where she is! Thank you! Terima kasih! Xie Xie!

SCENE 7

Setting: Dr. Charles' laboratory

Lucas: Dr. Charles? Dr. Charles?

Charles: Lucas? What are you doing here?

Lucas: I want to be a real boy. Turn me into a real boy so that mummy would love me. Are you my blue fairy? I have traveled long and far. And I have lost hope. I can't find the blue fairy.

Charles: My boy..*(to the animals)* are these your friends? how extraordinary! Come in, sleep for the night. You must be tired. *(puts them into bed)*

Lucas: *(prays)* Blue Fairy? Please...please, please make me into a real boy. Please...Blue Fairy? Please...please...make me real. Blue Fairy? Please, please make me real. Please make me a real boy. Please, Blue Fairy, make me into a real boy...Please...

On screen: So Lucas prayed for the Blue Fairy to appear for 1500 years.

SCENE 8

Setting: Laboratory

Blue Fairy: Lucas? Lucas? You have been searching for me, Lucas?

Lucas: For my entire life.

BF: And what have you come to ask me?

Lucas: I want to be a real boy. Please make me a real boy so mummy will love me, and let
me stay with her.

BF: Lucas, it's been 1500 years ago. Your mummy is no longer living. But, if you have some physical sample of the person, like a piece of hair, we might be able to work something out.

(Lucas gives the BF a piece of Jane's hair)

BF: Lucas, your wish is my command. *(BF takes the hair piece and places it into a machine and Jane appears)*

Lucas: Mummy?

Jane: Lucas!

Lucas: Mummy!!!

Lucas: Would you like some tea?

Jane: Yes.

Lucas: Just the way you like it?

Jane: Yes, my son.

On screen: And as our days are numbered, Lucas experienced the happiest day of his life. That was the everlasting moment Lucas had been waiting for. So Lucas and Jane lived together forever in their home. Lucas experienced what it means to be a real boy for the first time. He went to a place where his dreams came alive.